TODAY'S VICTORIOUS WOMAN
Volume I

Mrs. J. B. Livingston

QUALITY PUBLICATIONS
P.O. BOX 1060
ABILENE, TEXAS 79604

ISBN: 0-89137-426-4

Introduction

A few years ago I was asked to speak on a topic concerning older women teaching younger women in July at a Workshop. My first response was "no", but after listening to the workshop Coordinator's persuasive argument for a time, I agreed to consider it.

Several years before, an elder in one of the San Antonio churches had said, "Sister Livingston, our older women just are not teaching the younger women as they should." We agreed on this point. I asked permission to state an opinion. Permission for the statement was granted and that statement was, "Elders do not put the opportunity for this teaching in their curriculum." The elder replied, "I am going to think about that!"

Only a few months had passed when the telephone rang and this same elder said, "I've thought about what you said. How would you like to teach our Ladies' Bible Class for three months?" How could I say no?

This same elder had been the one who recommended that I speak at the workshop, and this fact was pointed out while I was considering the idea of speaking there. My husband expressed confidence in me and asked me to do it. So, on July 7, 1979, I stood before an audience of women in the River Room of the San Antonio Convention Center to conduct a three-hour seminar entitled "Today's Victorious Woman."

In response to many requests for outlines or lessons, or a book, here is an attempt to put the seminar into printed form with the prayer that it will be helpful to some of God's women.

Acknowledgments

To my niece, Kathryn King, whose confidence and encouragement meant more than she knows that it could mean;

To Stephanie, who, as a teenager, put me on a pedestal; and to whom the mellowing of teaching that comes with the years was a great disappointment;

To Evelyn Waterman, typist, confidante, encourager, and a wonderful christian example to all women, and

To my wonderful mother who moved out of her house of clay sixteen years ago, but her love and teachings are still a dominant factor in my life.

Mrs. J.B. Livingston

Foreword

The basis for this book was a three-hour seminar at a workshop of which the theme was entitled "Victory in Jesus," and it is divided into three parts:

Woman, (who is she?)

Bible Women, (creative or destructive?)

Victory In Jesus, CHRISTIAN.

It is the discretion of the publisher to divide the twenty-six lessons into two books dividing the book in part two, Bible Women. The crux of the entire study is in part three, woman as a Christian in every facet of her life, be it homemaker, professional, career, avocation, or retiree.

The hope of this writer is that you will study the entire twenty-six lessons in continuity to derive the most benefit from it.

May we allow God to continually help each of us in our struggle for victory.

Mrs. J.B. Livingston
December 28, 1982

Table of Contents

Volume I

Part 1

God,
Man, and Woman

Chapter One
MAN IN GOD'S IMAGE

Genesis 1 & 2; 1 Corinthians 15:39; Matthew 19:3-6

Man In God's Image

"In the beginning God created the heavens and the earth. The earth was without form and void, and darkness was upon the face of the deep; and the Spirit of God was moving over the face of the waters. And God said, "Let there be light, and there was light" (Genesis 1:1-3).

This begins the record of the creation of a perfect environment, complete, full grown, with laws of reproduction set in order, a place for man who was to be created in the image of God.

Then God said, "Let us make *man* in our image, after our likeness; and let *them* have dominion....So God created *man* in His own image, male and female He created *them*. And God saw everything that He had made, and behold, it was very good" (Genesis 1:26, 27, 31).

MALE FEMALE

Man-in-God's-image is *them*, male and female.

This is borne out in the English language and those with a knowledge of it are aware that the word " man" is a generic word meaning man and woman, male and female, humanity or can be used as masculine singular.

The terms chair*person*, fire*person*, mail*person*, are as offensive to many people as chair*man* or fire*man* is to others. It is one more of Satan's many wiles to confuse our tongue and foster the breakdown of communication.

Chapter 2 of Genesis is an account of the generations of the heavens and the earth when they were created. There was no man to work the ground so the Lord formed man of the dust from the ground, breathed into his nostrils the breath of life, and man became a living being. The Lord planted a garden in the East and there He put the man whom He had formed, to till it and keep it (Responsibility). Man could eat freely from any tree of the garden including the tree of life, "but of the tree of knowledge of good and evil you shall not eat, for in the day that you eat of it you shall die." (Restriction). (Genesis 2:17).

THE MAN, MALE,

 AND WAS GIVEN

1. Responsibility
2. Restriction
3. Freedom of choice

WAS MADE OF DUST

God did not create man to "do his own thing," but from the very beginning man has been required to:

work,

think for himself, and

obey God

or suffer the consequences. The responsibility and restriction was given to the man before woman was created.

Why Create A Woman?

"The Lord God said, "It is not good that the man should be alone; I will make him a helper fit for him" (verse 18).

All the living creatures were paraded before the man to be named by him, but for the man there was not found a helper fit for him.

Why was there no helper found fit for the man among the creatures? God had breathed into the man the breath of life and he became a living being, for one thing. For another, turn to 1 Corinthians 15:39 and hear what the Holy Spirit says by the pen of Paul.

"All flesh is not the same; there is one kind for men, another for animals, another for birds, and another for fish."

When no suitable helper was found for the man God caused a deep sleep to fall upon the man, took one of his ribs and closed up its place with flesh. (The first anesthesia and surgery?) God made the rib into a

10

woman and brought her to the man. (Woman, made from man, is made of finer material than the man, who was made from dust!) What was the man's reaction to the woman? "This at last is bone of my bones and flesh of my flesh; she shall be called Woman because she was taken out of Man" (2:23). A suitable helper had been made for the man, flesh and bones of the man, the female for the male.

God had created the woman for the man, full-grown, complete, with the ability to pro-create, and He gave them the command to multiply and fill the earth and subdue it (1:28). The first home was complete, one woman for one man, living and working in the garden in the presence of the Lord God.

Note that this home had three personalities. In its ideal state there was man, woman and God in full fellowship with one another, an unbeatable formula for a successful home.

A New Relationship

Because she was taken out of man, a man *leaves* his father and mother, (break one tie), *cleaves* to his wife, (make another one), and they become *one flesh.*

This can be illustrated by three pieces of string. Tie two pieces together with a slip knot (the tie with father and mother). Now pull them apart. *Leave* father and mother, break the first tie: (Parents, please hear this - let go!). Now tie one of those pieces to the third piece of string with a square knot to illustrate *cleave* to his wife and they become one. This square knot, when tied down tightly, cannot be untied without conscious effort, without manipulation of a wedge worked in between the two. So it is when a man and a woman *leave* their parents and *cleave* to each other; this union is broken only when an outside element is allowed to wedge itself between the two.

Let us look carefully at

LEAVE	*CLEAVE*
to give up	to adhere closely, to stick
relinquish	agree
desert	be faithful to
forsake	be united with, become one

Not only is this stated in Genesis 2:24, but Jesus, when questioned about marriage quotes this passage and adds "what God has joined together, let no man put asunder" (Matthew 19:3-6).

Dear Reader, consider this carefully!! Why did God create only one woman for the man?

11

What Is Woman

1. She is the FEMALE man!

Man had a need, (not to be alone).

Man-in-God's-image was incomplete until the woman had been made. Woman was exactly what the man wanted, bone of his bones and flesh of his flesh.

2. She is a *helper suitable* for the man.

3. She is God's crowning creation!

4. She is the fellowship the animals could not supply, companionship for the man.

5. She is a dual being, earthly, spiritual.

The man-ess, as some have said, was

Taken from his side, his equal,

Not from his head, to be dominated,

Nor from his feet, to be made a floor mat,

But from his side, to be loved and protected;

made from his own body, furnishing man with the occasion not only to love but to be loved.

God did not give the man dominion over everything He had created until he had a woman by his side, evidencing her exalted place in His creation.

Man - generic - was not complete until there was man-male, and woman-female. The female man was given two names, both bestowed by her mate:

1. Woman, because she was taken out of man, and

2. Eve, because she was the mother of all living.

For Private Meditation or Class Discussion
1. What had been completed before God created man?
2. Who made man?
 a. In whose image is man made?
 b. Explain man-in-God's-image.
3. Give the definitions of the word " man" in our English language.
4. What three things did God give the man to guide his conduct?
5. Why did God make woman?
6. How does woman differ:
 a. from the other creatures?
 b. from the man?
7. What command was given to them? (Genesis 1:28).
8. What three personalities were present in the first home?
9. What is man's responsibility toward his wife? (Genesis 2:24; Matthew 19:3-6).
10. What is woman?

Chapter Two

WHO IS WOMAN

1 John 4:8, 16; 1 Corinthians 11:7-12; Ephesians 5:28-33

In God's Image - Love

Woman is a helper fit for the man, man's complement, essential to the perfection of his being. Without her, the female, man-in-God's-image is incomplete.

God is love (1 John 4:8, 16). Love is a capacity essential to the integrity of God's nature. In providing the fellowship not to be found among the animals she completed the man in the image of God by furnishing him someone to love him, as he loved his own body, of which she is a part.

Man is to love his own body; because woman was made from man's body, to do so he must love his wife. Paul states this clearly in Ephesians 5:28-33. "Even so husbands should love their wives as their own bodies. He who loves his wife loves himself. For no man ever hates his own flesh, but nourishes and cherishes it, as Christ does the church, because we are members of His body. 'For this reason a man shall leave his father and mother and be joined to his wife, and the two shall become one'....let each one of you love his wife as himself, and let the wife see that she respects her husband."

Leave - Cleave - Love

From the beginning it was God's plan that one man be joined to *one woman*, and the two were to become one. This unity occurs in the sexual act (1 Corinthians 6:15, 16). Two are *not* to become one outside the marriage vow, before marriage and only with the marriage partner after marriage. Until one is ready to *leave* his parents, *cleave* to his wife, and *love* her as he loves his own body, he is not ready to make

15

himself one with another. To do so is to commit fornication, which is immorality, which is SIN, and can condemn one's soul to eternal punishment (Galatians 5:19-21).

An Help Meet - A Helper Fit (Suitable)

Woman is an help meet (KJV), a helper fit (RSV), a helper suitable (NIV), a partner (NEB) for the man, of man's flesh and bones. Let us look at some synonyms for the term help meet, or helper fit for the man:

	help meet	protecting helper	
1.	counterpart	female for male	
2.	completor	giver of life	
3.	adapter	man pleaser	⌈ sanctuary
4.	protector	makes his home a	{ refuge
5.	pursuer	pursuit is necessary	⌊ asylum
		after marriage	

These five synonyms for a helper fit for the man are used in several courses. This writer was first introduced to them by Susan Key in her seminar *EVE REBORN*. She has graciously given her written consent for the charts and terms from *EVE REBORN* to be used in this writing.

1. Counterpart - female for the male.

According to Webster's Collegiate Dictionary it is a thing that serves to complete or complement another. In the first home it was God's plan and purpose to place both sexes. There was no unisex in the Garden of Eden, nor were there home units with two males or two females. God made them male and female. Man, the male, needed a counterpart so God created the female.

2. Completor- without woman there was no life. Paul states this to the Corinthians:

the woman is the glory of the man;

man did not come from the woman, but the woman from the man;

neither was man created for the woman, but the woman for the man. For this reason woman ought to have a sign of authority on her head.

Woman is not independent of man, nor man of woman, for as woman came from man, so man is now born of woman.

And all things are from God. (1 Corinthians 11:7-12).

3. Adapter - man pleaser.

Adam was pleased with Eve. When dating, girls usually adapt to the boy's time schedule, his hobbies, and his family. She strives to please him.

4. Protector - his homemaker makes his home a refuge, a sanctuary, an asylum where he can be protected from outside pressures of job, friends, or other distracting worries. It is a place where he can relax and recreate himself. Protect your home from outside interference from any source.

5. Pursuer - pursuit *really* begins after marriage. The *man pleaser* who adapted herself to the man in courtship needs to learn that marriage is only the *beginning* of the relationship. For either mate to take the other "for granted" is a big mistake. Do not become a tormentor. Look back to the things you did while dating to get his interest and attention! It is even more important after marriage. Look for the good points in the man you married that attracted you to him. Quit looking for a man to love and love the man you married!

This brings to mind an incident related by a counsellor; a man had come to him for counselling for a marriage that had failed. In the course of the conversation the man stated that he had not loved his wife in years. The counsellor replied, "No wonder the marriage is failing. Quit disobeying God; go home and love your wife!"

Wife, make yourself lovable! Do what God says; respect (reverence) your husband. If you don't someone else will.

It is easy for a woman to love and respect a man who loves her, provides for her, and cherishes her as Christ loves the church and gave Himself for her. Mothers, please teach this to your sons.

In That Garden Home

In the Garden of Eden woman had everything she needed without tension or struggle. The man and woman, man-in-God's-image, walked and talked with God in the garden in the cool of the day, knowing no evil and experiencing full fellowship with God their Creator. Here they ate of the tree of life and enjoyed a toilless, painless existence. The man evidently communicated with his wife sharing with her the knowledge of responsibility, for we find a little later in our study that she certainly was aware of the restriction.

Restriction was given to protect the inner peace and harmony God had given them in the beginning. God alone knew how to distinguish GOOD from EVIL. Today the more Godlike we become, the more we exercise our senses to discernment, the more capable we are to distinguish good from evil (Hebrews 5:12-14).

In our culture today there seems to be a problem of identity for some women.

Why is woman? She *is* because God saw it was not good for man to be alone; man needed her.

What is woman? She is the female for the male, God's crowning creation, man's complement.

Who is woman? She is the helper fit for the man, his counterpart, his complement, his protector.

God said, "Let us make *man* in our image, and let *them* have dominion....So God created *man* in His image, male and female He created *them*."

For Private Meditation or Class Discussion

1. After woman's creation what godly emotion could the man exercise? (1 John 4:8).
2. Why must man love his wife?
3. How many women does a man need to fill his needs?
4. When do "the two become one"?
5. Why is sex-before-marriage wrong? (1 Corinthians 6:15,16).
6. Give five synonyms for help meet, or helper fit for.
7. In Ephesians 5:21-33:
 a. man is told to_____his wife.
 b. woman is told to_____her husband.
8. Describe woman's first home.
9. What helps one to distinguish good from evil?
10. Why ⎤
 What ⎬ is woman?
 Who ⎦

Chapter Three

EVE AND THE TEMPTER

Genesis 3; Matthew 4; 1 John 2:16

Why Eve?

In the Garden of Eden there was no unisex. The female-man that God gave Adam was different from the male-man. This difference was great enough to send the tempter to Eve instead of the male.

Through the serpent she was made to see the tree of knowledge of good and evil in a different way. He beguiled, he deceived Eve, by telling her that if she would eat the forbidden fruit she would gain for herself new delights, being as wise as the gods. In contrast, Adam was not deceived. (1 Timothy 2:14).

Eve's submission to the tempter, to
hear,
believe, and
obey him
Is an example of
1. woman's impulsiveness, and
2. man's inclination to follow.

Genesis 3 ascribes to woman the supremecy of influence. Woman has a special responsibility to see to it that her life influences those around her in a way that God can accept, to get herself and her family through earth to heaven.

Within God's will all human relationships are harmonious, full of real life and creative. The first self-interested impulse came by way of subtlety! And the first suggestion to disobey God came from the LOWER creation! "Now the serpent was more subtle than any other wild creature that God had made" (Genesis 3:1). Our temptations always come from the creature, not the creator.

21

An Unwise Choice

Two ways of life stood before the woman;
1. the tree of life;
2. the tree of the knowledge of good and evil.

She chose to believe the lie and reject the truth. She chose to eat of the tree of the knowledge of good and evil, used her influence on the man, and he ate of it. They exchanged the truth of God for a lie and worshipped and served the created things rather than the Creator (Romans 1:25).

We, too, have two ways before us. Just as Adam and Eve, our lives are the result of our choices. Are you choosing the lie and rejecting the truth?

Eve was tempted in three ways. John speaks of these three areas, things of the world, he states, and our Savior was tempted in the same ways.

Genesis 3	1 John 2:16	Matthew 4
1. good for food	lust of the flesh	rocks to bread
2. pretty to look at	lust of the eye	earthly kingdom
3. desirable to make her wise	pride of life	"Cast yourself down"

From Helper to Hinderer

Someone has facetiously stated it this way:
1. Adam's Rib
2. Satan's Fib
3. Women's Lib

At any rate the dual being became manifest. The earth man served the flesh rather than the spirit. The woman, created with a desire for peace, is self-styled, bent for chaos. Along with her ability to love is her ability to wound. When the creative woman serves the lust of the flesh, the lust of the eye, and the pride of life she leaves her creativity and becomes destructive. Instead of being a...

...helper she is now a hinderer,

...the counterpart becomes an opposer,

...the completor becomes competitive,

...the adapter becomes a self-server,

...the protector becomes an exposer,

...and the pursuer becomes a tormentor.

Instead of helping her husband in his responsibility and restriction Eve has now weakened Adam. Her influence led the male into disobedience, into exchanging the truth of God for a lie; he willingly follow-

ed her lead.

The counterpart becomes the opposer. She may have felt that she was just wanting the best for her mate, with no thought of being destructive. But, she was opposing him in his responsibility - in his job!

The completer becomes the competitor. Instead of consulting the other member of the team she ran ahead.

The adapter becomes the self-server. The fruit was pretty to look at; it looked like good food; it would enhance her intelligence; so she took it to please herself without consulting her husband or her Creator.

The protector becomes an exposer. She caused a break in the relationship between her husband and his "employer", exposing him to a much harder way of life. He would now earn his bread by the sweat of his face, and instead of gathering what was available in abundance he would have to plow through thorns and thistles.

Because he listened to his wife and ate of the tree about which God had commanded, "you shall not eat of it", the man was driven from the presence of God.

(The first man *listened* to his wife and got into serious trouble for it. Could this be the reason why some husbands no longer *listen* to their wives?)

Woman Loses Equal Rights

The woman stepped outside her bounds as a *helper* suitable for the man and lost her equal rights. She forfeited the respect and confidence which entitled her to equality of authority in family affairs.

The penalty for her ill-fated leadership is twofold:
1. greatly increased pain in childbearing;
2. your husband will rule over you.

In Genesis 3:16 and 1 Timothy 2:11-14, please note that God said to the woman, "Your husband shall rule over you." Do you know of a passage where the man is told to *rule* the wife? If so please share the information. God gave the man the responsibility of head of the family but did not make him "the boss". Woman must voluntarily give the man the rule.

HEADSHIP DOES NOT DENOTE SUPERIORITY!

Please hear this. Headship does not denote superiority! Dependence denotes difference of function, not inferiority. There is no place for tyranny in the husband-wife relationship.

Woman Glorified

God declared that the SEED OF WOMAN would bruise the head

23

(limit the power) of the serpent (Genesis 3:15). This is the first prophecy of Christ; read the fulfillment in Galatians 4:4 and Hebrews 2:14.

Woman was glorified by being permitted to bring into the world the SEED, the only begotten Son of God, to bring back fallen man to God.

But the first woman, the mother of all living, made a big mistake. She used poor judgment, portraying woman's vulnerability by allowing Satan to deceive her.

Satan is alive and doing well today! BELIEVE IT! He still recognizes the difference God created in the male and female, and in his craftiness he still appeals to our self interest.

Why, today, do salesman prefer to approach "the lady of the house" with their salespitch? Why is advertising geared to women? Why does advertising for items usually purchased by men have near nudes, or otherwise appealing females used to promote cars, tractors, cigars, razors, chain saws, or hardware?

God designed the roles of man and woman to be different when he made them male and female. The difference is not only physical but also emotional and temperamental.

Ancient Hebrews held women in high esteem, honor and affection, as we will see in our study of women of the Bible. Christianity completed the work of her restoration to spiritual equality of opportunity and place. Wherever the teachings and spirit of Christianity prevail she is the loved companion, confidante and advisor of her husband. The more Christ-like she is the more equality she attains.

Under the Law of Moses the children were required to honor mother equally with father. "Honor your father and mother," states the fifth commandment (Exodus 20:12). The wise man, Solomon, agreed with this in Proverbs 6:20; 1:8, "Forsake not the law of thy mother."

The woman said, "The serpent beguiled me and I ate" (Genesis 3:13; 2 Corinthians 11:3). Thus the knowledge of good and evil entered God's creation through the woman who used her influence on the man, and the battle between good and evil has burdened mankind ever since that day.

For Private Meditation or Class Discussion

1. With whom did the serpent engage in conversation?
2. Why did the woman hear, believe, and obey the serpent?
3. Why are we concerned with the three ways she was tempted by the fruit?
4. How is the dual being exposed in this incident?
5. How was the role of the woman affected by her disobedience?
6. What penalty was imposed upon the woman?
7. Did God make the man his mate's "boss"?
8. Where do we read the first prophecy of Christ?
9. How was woman glorified? When?
10. Is Satan deceiving man today? How?

Chapter Four

THEY KNEW THEY
WERE NAKED

Genesis 2:24, 25; 3:7, 2l; Romans 5:12; Hebrews 4:13; 2 Corinthians
5:2, 3; Revelation 3:17, 18

Their Eyes Were Opened

The woman and man had been given the command to be fruitful
and increase in number; God had said that the man was to be united to
his wife and the two would become one flesh. "The man and his wife
were both naked, and they felt no shame" (Genesis 2:24,25). They
were in a state of complete innocence knowing no evil.

Yet immediately after the woman and her husband ate of the tree of
knowledge of good and evil their eyes were opened and they knew they
were naked. We know this because they sewed fig leaves together to
make coverings for themselves.

Their shame was caused by their disobedience to God, which is sin.
They attempted to cover their nakedness by using their own resources,
then tried to hide it from God. By their own actions they revealed their
disobedience (verses 8-13). Sin is covered only by the blood of
sacrifice, so the first blood was shed when God made coats of skins
and clothed Adam and Eve (verse 21).

Fortunate indeed is the individual whose eyes are opened to his sins
and goes to the cleansing blood of the Lamb of God to be washed.
Perhaps there is a need for the fruit of that tree today so people would
be aware of shame when they parade on our streets naked, or nearly
so.

Two Become One

After sin came into the world through Adam God made only one
change regarding His charge to the man and woman to increase and

27

fill the earth; He told the woman she would now have multiplied pain in childbirth. The sexual desires they now had were the same as they had been in the Garden of Eden. Sexual desires are God-given, and are good. God saw that man needed only *one woman* to meet his needs.

The idea that sexual desire is evil is foreign to God's plan. Because of the abuse of this good, some wrong conceptions have been taught. Many marriages have had trouble because the bride had been taught not to let a man touch her, especially in an embrace, lest she get pregnant and disgrace herself *and her family*. It came as a bit of a surprise to this writer to be told by some young wives that even in today's permissive society this is still a big hang-up with christian girls.

It is in the sexual union that two become one flesh (Genesis 2:24; 1 Corinthians 6:15-18). God meant for this relationship to be a fulfilling, enjoyable part of the lives of husband and wife. The sexual union is more than just a physical act since it involves a much deeper soul relationship between the two. Without the love of one for the other and the inner oneness expressed in marriage the sex act becomes an improper union of bodies.

God put restriction on gratification of sexual desire limiting it to the bounds of marriage - one woman for one man who LEAVES father and mother and CLEAVES to his wife.

Listen to Jesus answering the test question from the Pharisees (Matthew 19:3-6). They asked, "Is it lawful for a man to divorce his wife for any and every reason?"

"Haven't you read," He replied, "that at the beginning the Creator made them male and female and said, 'For this reason a man will leave his father and mother and be united to his wife and the two will become one flesh'? So they are no longer two, but one. Therefore, what God has joined together, let man not separate."

In the sexual act two become one! God put a fence around it - marriage. When two become one before marriage it is fornication; fornication is immorality, which is a work of the flesh. Paul wrote to Corinth stating, to avoid fornication every man should have his own wife and each woman should have her own husband. After marriage each should fulfill his marital duty to the other. The wife's body belongs to the husband and the husband's body belongs to the wife. One is not to deprive the other except by *mutual consent* and for a short time to devote yourselves to prayer (1 Corinthians 7:1-5).

Ladies, to use your bodies as weapons to punish or reward your husband is contrary to God's will! Read this passage of scripture carefully!

One Woman For One Man

Monogomy is the divine ideal for man, one woman for one man. When two become one that relationship is one in which God legislated that they are joined together, and man is not to separate what God has joined together. The first infraction of this ideal is recorded in Genesis 4:19. Lamech, the descendant of Cain, who had been separated from God by his own evil ways took two wives. This Lamech is not to be confused with Lamech the father of Noah the righteous.

God did not establish nor condone a double standard of morality for man and woman. He did create differences in the bodies, personalities and temperament of men and women without inequality. Woman is not inferior; man's headship is the result of woman's impetousness and poor judgement. Each has his role and function in the home. There is NO WAY THAT TWO MALES or TWO FEMALES can fill these functions in the home. *Homosexuality has no place in God's plan.*

In Romans 1:22-27, speaking of godless and wicked men, the Holy Spirit inspires these words:

"Although they claimed to be wise they became fools and exchanged the glory of the immortal God for images made to look like mortal man and birds and animals and reptiles.

Therefore God gave them over in the sinful desires of their hearts to sexual impurity for the degrading of their bodies with one another. They exchanged the truth of God for a lie, and worshipped and served created things rather than the Creator -who is forever praised. Amen.

Because of this God gave them over to shameful lusts. Even their women exchanged natural relations for unnatural ones (Lesbians). In the same way the men also abandoned natural relations with women and were inflamed with lust for one another. Men committed indecent acts with other men (Homosexuals) and received in themselves the due penalty for their perversion."

Anyone who loves God and seeks to please Him through obedience to Him, to the teaching of His word CANNOT rationalize that homosexuality is anything but sin in God's sight; homosexuals are not to be recognized as a credible minority in society and their actions are not to be condoned. Love the sinner but hate the sin, and CALL IT SIN, in order to save the sinner.

Mothers, investigate that sex-education course being taught in your schools. Determine if it is teaching homosexuality and other perver-

sions as an acceptable alternate life style to that which God has given.

Spiritual Nakedness

Nakedness is often used synonomously with sin in scripture. Examples are: Exodus 32:25 (KJV), describing the behavior of Israel when Aaron made the golden calf at Sinai; Revelation 3:17,18, describing the church at Laodicea; and Revelation 16:15. In 2 Corinthians 5:2,3, Paul writes of our need for spiritual clothing and the church at Laodicea was admonished to wear white clothes to cover their shameful nakedness.

Modest dress is always commanded of God's people along with a chaste life. Greece and Rome fell far below the Hebrew conception of woman's worth. Aristotle, Socrates, Domosthenes and Plato downgraded womanhood and marriage. Chastity and modesty were foreign to the Greek conception of morality - they worshipped public prostitutes.

Every decline in the Hebrew woman's status was due to the incursion of foreign influence, never from God's teaching. The nearer mankind is to God and His ways the higher the woman is esteemed and valued.

Laws of modesty and chastity were not confined to women. God forbade adultery and incest in the law of Moses. "Thou shalt not *uncover the nakedness* of thy father's wife, thy sister, thy son's nor thy daughter's daughter," and he lists many other kinsmen in this list in Leviticus 18. Solomon wrote much in the Proverbs about young men keeping themselves free from the entanglements of the adulteress and the seductive woman, the immoral woman and the prostitute.

Spiritual Clothing

Paul wrote to the Ephesians, "among you there must not be even a hint of sexual immorality, or of any kind of impurity, or of greed, because these are improper for God's holy people," and to the Colossians, "Put to death whatever belongs to your earthly nature: sexual immorality, impurity, lust, evil desires and greed which is idolatry. You must rid yourselves of all such things as these: anger, rage, malice, slander, and filthy language from your lips.

Clothe yourselves with compassion, kindness, humility, gentleness and patience. Bear with each other and forgive as the Lord forgave you. Over all these virtues *put on* love, which binds them all together in perfect unity."

To the Thessalonians he wrote, "It is God's will that you should be holy; that you should avoid sexual immorality; that each of you

should learn to control his own body in a way that is holy and honorable, not in passionate lust like those who do not know God.''

"Marriage should be honored by all, and the marriage bed kept pure, for God will judge the adulterer and all the sexually immoral'' (Hebrews 13:1).

Be clothed with:
compassion,
humility,
gentleness,
patience,
love,
the full armor of God,
Christ.

Because when we are clothed, we will not be found naked (2 Corinthians 5:3). "He who overcomes will be dressed in white. I will never erase his name from the book of life'' (Revelation 3:5).

"Let us rejoice and be glad and give him glory!

For the wedding of the Lamb has come,
and His bride has made herself ready.

Fine linen, bright and clean was given to her to wear,''
(Fine linen stands for the righteous acts of the saints) (Revelation 19:7,8).

For Private Meditation or Class Discussion

1. After eating the fruit, of what were Adam and Eve aware?
2. Why was their attempt at clothing themselves inadequate?
3. Are sexual desires wrong?
4. From the beginning what is God's plan for marriage?
5. When do two become one? Give a New Testament passage for this.
6. Why cannot homosexuals make a godly home?
7. Nakedness is sometimes used in scripture as a synonym for what?
8. Does God give a double standard of morals for male and female? Explain.
9. With what are we to be clothed? Give passage.
10. How will the Victorious be dressed?

Chapter Five

ME? SUBMIT?

Genesis 3:16; Romans 13:1-7; Philippians 2:4-9; Ephesians 5:1-33

Submission. What Is It?

To the woman He said, "I will greatly increase your pain in childbearing; with pain you will give birth to children.

Your desire will be for your husband and he will rule over you."

Before you turn a deaf ear stay tuned in long enough to take a look at the picture.

Are you one of the many who are *submitting* to peer pressure of the Woman's Movement to rebel against submitting to your husband? First of all remember that God did not command the man to rule the woman; it is the responsibility of the woman to have the man rule over her.

Let us look at submission around us in our daily lives.

Defined, submission is:

voluntary subordination;

to yield, resign, or surrender to power, will, or authority;

yield or defer to another;

to give precedence.

Submission. To What?

1. *Society*

Why do so many people desire new and better houses, with four bedrooms, 2½ baths, carpeting, 2 or more TV's, radar range, new cars, the best school district, etc., etc.? These things are not necessarily bad, but why do they make so much difference? It is because we submit to the standards our society sets for us.

2. *Fashion*

How many clothes have you taken to a garage sale, to a clothing room at the church building, given to charity, or taken to a pre-owned clothing store for resale? Why did you dispose of them? Was it because they are no longer fashionable?

Why were skirts too short to be called modest and men's trousers bell bottomed at one period and the next year skirts were mid calf and men's slacks straight, slim cut? Fashion! You fill in all the ways we submit to fashion.

3. *School Systems*

After moving into the school district of our children's choice who determines what is being taught? Who chooses the text books?

Who writes the text books?

At what age are they taught Darwin's theory of evolution as fact and not theory?

Have they learned disco dancing in school this year?

Does your school teach sex education? If so, of what does it consist? Is it a biological approach, or is it teaching various sexual lifestyles (homosexuality, sexual perversion, etc.)? Is your child being taught in the schools to make his own choice as to type of sexual lifestyle?

This is said to make you aware, hopefully, of how completely and often unquestionably we submit to our school systems.

4. *Children*

Oh! Do we ever submit to our children? Who was the deciding factor in:

where you would live in your city?
what you buy at the grocery store?
what they will wear?
what you will wear?
what they will eat? and when?
what you will eat?

Oh, they do not make out the grocery list or pick out your clothes, but do you budget for what you want and buy for them with what is left?

Who decides how you will spend your time? Do you make out your time calendar, then chauffeur the children to school, little league, dentist, band practice, boy or girl scouts on YOUR time schedule? Of course not.

The point is this - how much do you submit to your children?

5. *Television*

Who controls the programming? Not you. Who controls the on-off switch? Hopefully, you *do* have some control over that. Who con-

trols the time of the football broadcasts? You are thinking of other areas in which we submit to the television.

6. *Telephone, Repairmen*

We submit to *when* it rings, to *who* is ringing it, even when it rings at meal time or during the afternoon nap; and when the calls are from repulsive salesmen.

We submit to repairmen,
 when they will come and
 what they will charge.

The list could go on and on; the passions of our body, hunger, thirst, fatigue, sexual desires. These desires are all God given and there is nothing wrong with submitting to them within the fences of safety with which God has surrounded them.

7. *Law of the land*

God requires us to submit to the laws of the land. Let us look at a few scriptures:

1 Peter 2:13 - Submit yourselves for the Lord's sake to every authority among men, whether to the king as the supreme authority, or to governors who are sent to punish those who do wrong or to commend those who do right.

Titus 3:1 - Remind the people to be subject to rulers and authorities, to be obedient, to be ready to do whatever is good.

Romans 13:1-7 - Everyone must submit himself to the governing authorities for none exist except that which God has established. The authorities that exist have been established by God. Consequently, he who rebels against authority rebels against what God has instituted and will bring judgment on himself. It is necessary to submit to authorities not only because of punishment but also because of conscience.

"This is why we pay taxes, for the authorities are God's servants, who give their full time to governing. Give everyone what you owe him: if you owe taxes, pay taxes; if revenue, then revenue; if respect, then respect; if honor, then honor."

We submit to the law of the land;
Why do we pay Sales tax,
 Income tax,
 School tax,
 City tax,
 State tax,
 Federal tax?

Because God said, "If you owe taxes, pay taxes." Why do we

drive 55 MPH? Because it is a safe speed, and if we get caught going much faster we will have to pay a fine.

Do Others Submit to Me?

Certainly! Our children,
 our neighbors,
 our students,
 our friends,
 our husbands.

There are many times when others voluntarily defer to our desires and decisions and authority. There are certain realms of our homes that are ours and others defer to us in using that area.

The Mind of Christ

Since we are continually submitting to people and situations, WHY IN THE WORLD DO WE REBEL TO SUBMITTING TO OUR HUSBANDS? To the most important person in your life? The one with whom you are united to be one? The one to whom you cleave?

Subjection is primarily a military term - to rank under. God set the order of rank, the divine order:

God
} creator - equal
Christ

man
} the created - equal
woman
 (1 Corinthians 11:3).

This is not a relationship peculiar to christianity. It was established by God in the beginning.

Paul writes through guidance of the Spirit: "Each of you should look not only to your own interests, but also to the interests of others. *Your attitude should be the same as that of Christ Jesus.*"

What was His Attitude?
God exalted Him to the highest place,
gave Him the greatest name,
and all knees will bow before Him, and
every tongue will confess Him as Lord. (Philippians 2:4-9).

Submission is something only the individual can do - I cannot submit you, nor you me. Christ became subordinate voluntarily to God His equal. Was He inferior? No.

Man is in subjection to Christ - Christ has the authority over the man and man is commanded to be submissive to Him. Woman is in subjection to man whom God ranked in authority over the woman.

36

Both are created beings.

Since man has the authority is he superior to woman? No! Nothing in God's word indicates that he is. There has to be someone in authority in anything we undertake or the result is chaos. God is a God of order and we are commanded to do things decently and orderly.

In God's plan woman is not inferior, but she does rank last in authority. Let us thank God for protecting us from that responsibility.

Submit to One Another

Let us look at Ephesians 5:1-33. Verse 21 commands, "Submit to one another out of reverence for Christ, (in the fear of God, KJV). Paul starts out by saying, "Be imitators of God as dearly loved children and live a life of love just as Christ loved us." If we read all of the chapter we see that Paul is describing a new relationship which the christian lives. He has come out of darkness into the light of God (verse 8).

Live as children of light;
Live wisely, do not be foolish;
Understand the Lord's will;
Don't get drunk on wine;
Be filled with the Spirit;
Communicate in psalms, hymns and spiritual songs,
Sing, make music in your heart to the Lord,
Be *thankful* for *everything*;
Submit to one another out of reverence for Christ.

A new christian is not only changed individually, he is transformed toward others. The basis of the new relationship is *SERVICE*. Jesus said that the Son of Man did not come to be served but *to serve*. (Matthew 20:28). To be Christlike one changes his attitude. Out of respect (reverence) for Christ he surrenders his ego-centered desire for dominance in a relationship and accepts the role of one who serves.

Here submission means a *readiness to meet the needs of others*.

Ephesians 5:21 - 6:10 deals with relationships:

husbands and wives
parents and children
slaves and masters.

Each relationship submits to service out of respect for Christ. Bob Hendren states it well in his book *Chosen For Riches*:

"Subjection is not a one-way proposition. Men must be submissive, too. How can this work? How can a husband subject himself to his wife and still have his wife submit to him? He submits as he accepts his responsibility to be the head of the wife in the Spirit of Christ; a spirit

of service, not dominance. He serves her needs" (page 139).

Hendren pictures the husband as the initiator and the wife as the responder.

Wives, submit to your husbands as to the Lord. Why? For the husband is head of the wife as Christ is head of the church, the savior of it, His body. Now as the church submits to Christ, so wives must submit to their husbands in everything.

Husbands, love your wives just like Christ loved the church. In the same way, men should love their wives as their own bodies (Genesis 2:24). He is to love his wife as he loves himself, his body. Love your wife - bone of your bones and flesh of your flesh.

"This is a profound mystery - but I am talking about Christ and the church. However, each one of you must love his wife as he loves himself, and the wife must respect her husband."

C. R. Nichol makes a beautiful statement about this in his book, *God's Woman*:

"Are you impressed with the fact that the apostle, instead of comparing the relationship of Christ and the church to that of the husband and wife, compares the relationship of the husband and wife to that of Christ and the church? He takes the divine relationship to illustrate and impress that of the human; he illustrates the earthly by the heavenly rather than the heavenly by the earthly. Christ loved the church and gave himself for it; so the husband loves the wife, and if need be will sacrifice his life for her. This being true HE WILL NOT IMPOSE ON HER ANY CONDITION OR REQUIREMENT SHE WILL NOT BE GLAD TO MEET" (Capitals mine, pages 87-88).

To have the mind of Christ woman will empty self of self, will be submissive and will happily serve. To have the mind of Christ woman will submit to her head, her husband, just as the church submits to Christ, its head.

This is God's Plan

God,
 Christ,
 Man,
 Woman; God's pattern.
God and Christ won't break it -
Something goes wrong when man fails to live by it,
Or when woman rejects it.
 Make your husband happy-
 Let God make him godly!

For Private Meditation or Class Discussion

1. Define the word submission.
2. Why are we concerned with it? Genesis 3:16b
3. Name at least five things to which we daily submit.
4. Why do we pay taxes?
5. What is God's divine order of rank? Give scripture.
6. What was Christ's attitude toward submission?
7. What is His rank with God? Philippians 2:6
8. What is the basis for a transformed life?
9. How does submitting to one another revere Christ?
10. What is God's pattern for a happy marriage?

Part 2

Bible Women

CHART

CREATIVE WOMAN	DESTRUCTIVE WOMAN
Help meet—As Created	Hinderer
Counterpart	Opposer
Completor	Competitor
Adapter	Self-server
Protector	Exposer
Pursuer	Tormentor

Chapter Six

NOAH'S WIFE, SARAI, LOT'S WIFE

Genesis 6-9; 12-23

Earlier in this book you read about Eve, the first woman, who was created a helper fit for the man, and how when she stopped being a helper she became destructive.

Let us look at some other Bible women.

Noah's Wife

She is unnamed as a woman, but as a wife we see her as a counterpart, a completor, an adapter. She gave Noah three sons. She was willing to move into a big awkward boat before rain had ever fallen. Probably it was because of his wife that Noah was found to be righteous in God's sight and was chosen, with his family, to be saved from the destruction of the flood.

As a mother she trained three sons who chose wives who were adapters, also, and for a year these eight people lived in the ark with all the animals, leaving it to enter a new world inhabited only by them.

Sarai

The wife of Abram, she can be considered an example of the creative woman in every way. She was a *helper* suitable for him, a *counterpart* and a *completor*. Certainly, she was an *adapter*.

According to archeological evidence and scholarly study she enjoyed a luxurious, socialite existence in Ur of the Chaldees. We know her as an intelligent, opinionated woman, yet she had the elasticity to follow Abram submissively, not knowing their destination.

Abram could trust her emotional equilibrium under fire! She followed her husband into a nomadic life, not as a shadow, but as a strong influence (Genesis 11 and 12). Are you adventuresome enough

to be God's woman as Sarai was?

Along with her husband she experienced a name change. Sarai became Sarah, a mother of nations; Abram became Abraham, a father of many nations. She was Abraham's *protector* as well as a *pursuer*. At age sixty-five-plus her husband considered her beautiful and desirable, asking her to lie to the rulers of Egypt and Gerar, saying she was his sister instead of his wife so that they would not kill him and take her (Genesis 12 and 20).

Yet this creative woman had weaknesses. She laughed at God's promise that she would bear a son. After ten years of waiting for God's promise to be fulfilled to Abram that they would have a son she ran ahead of God, suggesting that Abraham take Hagar, her Egyptian handmaid, for a wife to bear him a son. Abraham *submitted* to Sarah's suggestion and Hagar bore Ishmael, (an act that has caused much heartache for almost 4,000 years).

The result of this union brought out in Sarah's dispositon her jealousy, her vengeful attitude, blame-shifting, and a refusal to accept the responsibility for her own desires. Turning to Abraham she said, "My misery is all your fault. I put my servant in your arms; now she is pregnant and despises me." Abraham answered, "Your servant is in your hands; you just do whatever you think best, dear." So she mistreated Hagar to the point that Hagar tried to run away.

God does not get into a hurry as we mortals do. Fourteen years later Sarah bore her own son, Isaac, the son-of-promise. Soon afterward Sarah insisted that Hagar and Ishmael be sent away. Again Abraham *submitted* to his wife although he was greatly distressed because it concerned his son Ishmael, and he sent them away (Genesis 21).

Yet Peter writes of Sarah in 1 Peter 3:6 that she was a submissive wife,
> who obeyed Abraham,
> and called him lord (sir).

"You are her daughters if you do what is right, and do not give way to fear."

Do you give way to:
FEAR of submission?
FEAR of ridicule of peers?
FEAR of being unfulfilled (whatever that means)?

Most unfulfilled lives need only to be submitted to God to reach fulfillment.

Sarah is named with Abraham in Isaiah 5:2; speaking to the righteous, Isaiah says, "Look to Abraham your father, and Sarah

who gave you birth.''

She stuck by her husband; nothing divided them; not adversity, nor prosperity, nor famine, nor Hagar, nor the pomp of Pharaoh's court. She is named in the roll call of the faithful in Hebrews 11:11. She is the only woman whose age is given at her death. Abraham bought an especial burying place for her in the land God promised to them.

Lot's Wife

In contrast, look at Lot's wife.

When Abraham and Lot separated, Lot "pitched his tent *toward* Sodom.'' When the angels of the Lord entered Sodom Lot was sitting in the gate of the city, a place of judgment and honor. Peter calls him a righteous man who was distressed by the filthy lives of lawless men (2 Peter 2:7).

At what point did Lot move from "toward Sodom'' into the gate?

Was his wife a suitable helper for him?

Why had his family moved into Sodom?

Depending upon which version of scripture one uses, Lot's wife (unnamed) is given a 12 - 15 word biography, "But Lot's wife looked back and she became a pillar of salt'' (Genesis 19:26).

She was not *adaptable*. She loved Sodom and her possessions there too much to give them up. She could not bring herself to flee iniquity. The influence of the move into Sodom is seen in her daughters who committed incest with their father, producing the nations of Moab and Ammon, nations who battled Israel for many years.

Lot's wife is a symbol of a woman who refused to move forward. Our Lord gives her a 3-word memorial in Luke 17:32. Speaking to His disciples concerning His second coming, and warning of unpreparedness, He says, "Remember Lot's wife.''

There are many ways for a woman to make a name for herself! Remember Lot's wife!

Are you chained to your past? Do your possessions possess you? Even God could not free Lot's wife, because she did not want to be freed. Are you solidified in your ways as Lot's wife was solidified into a pillar of salt, or are you adaptable?

For Private Meditation or Class Discussion

1. As a wife what creative qualities are seen in Noah's wife?
2. As a mother what creative quality can be seen in Noah's wife?
3. In what ways is Sarai seen as a creative woman?
4. How was Sarai her husband's protector?
5. Did Sarai portray any destructive qualities? Explain.
6. How does Peter picture Sarai? Of whom else are we said to be daughters if we do right?
7. What are we actually told about Lot's wife?
8. What qualities do you see in Lot's wife?
9. What memorial to Lot's wife is stated by Jesus?

Chapter Seven

REBEKAH, LEAH AND RACHEL, AND TAMAR

Genesis 24 - 28:5; 29 - 35; 38

Rebekah

Isaac, the son-of-promise, had his wife chosen for him from his father's people. His own mother was dead and his father remarried, but there is no record of any dissent between Isaac and Keturah or his six half-brothers, an indication that his own marriage was a good one.

Rebekah thrived on a challenge. Like Sarah, she got up and moved with her husband over and over again without any recorded grumbling.

"Isaac came to love her," a woman he had not seen before. Rebekah made herself lovable! Isaac found consolation after his mother's death in this woman he came to love. She was a completor, comforting her husband who for forty years had been his mother's only child. Like Sarah, Rebekah was genuinely devoted to her husband, protecting him when he told Abimelech, king of Gerar, that she was his sister.

For twenty years Isaac and Rebekah lived together without children. In answer to Isaac's prayer to God she became pregnant with twins, Esau and Jacob. As a mother she showed partiality to her younger son, and in doing so she became her husband's opposer and tormentor.

Leah and Rachel

Sarah's grandson, Jacob, awoke one day with two wives, a predicament for a man even in those times. In his youth Jacob had practiced deception and now he reaps what he has sown.

Leah was unloved, Rachel was much loved.

47

Leah was the dull one who gave;
 Rachel was the charmer who expected to receive;
Leah was meek, submissive, and gentle,
 Rachel was petulant, peevish and self-willed;
Leah was plain, loyal, a helper,
 Rachel was beautiful and spoiled.
God turned Leah's mourning into praise, and she bore Jacob four sons;
 Rachel had empty arms, with a heart that longed for children.
Leah demonstrated contentment in trial, neither envying nor complaining;
 Rachel had strife with both her husband and her sister, demanding of Jacob, "Give me children or I will die", and bargaining with Leah for her mandrakes.

After seeing Leah's four sons, Rachel, the one with creative beauty and the ability to give pleasure - the receiver - succumbed to competitiveness, and gave Bilhah, her handmaid to Jacob.

Leah, responding to the competitive spirit, gave her handmaid, Zilpah, to Jacob.

Competiton smothers gratitude! Women bring out surprising behavior in one another!!

Leah bears Jacob two more sons and a daughter, and Rachel is granted a son at last. Jacob now has eleven sons and a daughter, and has been in Haran twenty years when he thinks about going home.

However, Jacob made no decision about going home until he had consulted with his two wives who stood united in this decision. They considered themselves equal, as did he.
Leah had faith in her husband and in his God;
 Rachel was interested in material things and took her father's household gods, even lying to him about them.

Leah's son, Judah, became the father of the Messianic line - Boaz, Jesse, David and Jesus (Ruth 4; Matthew 1). Her son, Levi, was the father of the priesthood (Hebrews 7:11-16) and Leah was buried in the cave of Macpelah with Abraham, Sarah, Issac, Rebekah and Jacob (Genesis 49:29-32).

Rachel died in childbirth with Benjamin, and was buried in Bethlehem (Genesis 31:15). She is memorialized in Matthew 2:18.

Leah and Rachel are co-honored in Ruth 4:11, "Leah and Rachel did build the house of Israel." God helped them through the predicament of their circumstances, and in the two wives together we see the creative traits, counterpart, completor, adapter, protector, pursuer;

and in Rachel we see an opposer and tormentor.

Leah demonstrates creative giving without expectation; Rachel, creative beauty with ability to give pleasure, but primarily a receiver. Both qualities are needed for a balanced personality.

Tamar

One more woman in Genesis deserves our notice. Many biblical studies omit her, yet God saw fit to interrupt one of the most forceful narratives of Old Testament history to tell us about Tamar.

Judah, after losing two sons because of their unrighteousness, had failed to live up to the levirate law for brothers by giving Tamar his youngest son for a husband. We see Tamar as a woman who used legal means to protect herself and her family rights even though she deceived unrighteous Judah to do so.

Tamar is proof conclusive that there is something in a way a woman dresses! She took off her widow's clothes and dressed and conducted herself in a way to indicate to Judah that she was a prostitute. He left his staff and seal with her as a pledge of payment for services rendered, then she changed back into her widow's clothing.

She became pregnant with twins, Judah's sons Perez and Zerah. God honored this pregnancy by allowing Perez to carry on the Messianic line of Judah, the forefather of Jesus, and Tamar is one of four women mentioned in the genealogy of our Lord (Matthew 1:3).

Surely Rachel and Tamar are proof to us today that man's ways and God's ways are far apart. Who of us would not have allowed Rachel the honors allotted to Leah; or would have allowed Tamar to carry on the blood line of God's Son?

For Private Meditation or Class Study

1. How was Rebekah related to Sarah?
2. Why did Isaac love this wife whom he did not select himself?
3. How was Rebekah Isaac's
 a. protector?
 b. opposer?
4. What traits made Rachel lovable to Jacob?
5. How is the competitive spirit brought out between Leah and Rachel?
6. When Jacob consults his two wives about going to his home does he show any partiality?
7. As Jacob and his wives leave Aram what opposite traits are shown in the women by what they take with them?
8. Name three honors accorded Leah and her sons.
9. Was Tamar doing right when she dressed as a prostitute? (Do clothes make a difference today?)
10. Which of Judah's sons carried the Messianic line?

A PATRIOT, A LAWSUIT AND A PROSTITUTE

Exodus 2:1-10; 15:20,21; Numbers 12; 20:1; 27:1-11; Joshua 17:3-4; 2:1-21; 6:17-23

Miriam

In Exodus we find the account of Miriam, the sister of Moses. As far as the Bible record goes she was a single woman, unmarried yet fulfilled. Her interest was national; her mission was patriotic. In fact, she can be designated as the first woman patriot. She led in the recognition of the turning point in Israel's religious development.

As a little girl she showed her courage as she watched over her baby brother whose death the king had commanded; and eagerly went to get her mother to care for the child when Pharaoh's daughter took him for her own.

She is called a prophetess in Israel, a woman inspired to teach the will of God.

Miriam is the first woman singer on record, using her talents to elevate her people. She played the timbrel and the harp, and danced joyfully as she led Israel in singing the Song of Deliverance, the first national anthem.

Micah 6:4 names Miriam along with Moses and Aaron as deliverers of Israel from the bonds of Egypt.

But her earthly side rears its ugly head; she suffers a spiritual fall when she shows her destructive side and speaks against her brother, Moses. She also uses her strong womanly influence on Aaron to side him with her against Moses. She is no longer a leader in exultation, but a leader in jealousy and bitterness.

In His disapproval of her actions God smites her with leprosy. Because of the intervention on the part of the brother against whom

she spoke, God healed her of her leprosy.

Our last scene of Miriam is at Kadesh at her death and funeral.

"And Israel mourned for her thirty days."

Miriam loved God,
 believed Him,
 believed in Him.

She lived her single life creatively, fruitfully and interestingly.

Creativity flourishes where God is central.

Daughters of Zelophehad

These girls were the first women to claim inheritance rights and to sue for property rights. Theirs is one of the earliest lawsuits on record (Numbers 27:1-11; Joshua 17:3-4).

"The daughters of Zelophehad son of Hepher, the son of Gilead, the son of Makir, the son of Manasseh, belonged to the clans of Manasseh son of Joseph. The names of the daughters were Mahlah, Noah, Hoglah, Milcah and Tirzah. They approached the entrance to the Tent of Meeting and stood before Moses, Eleazer the priest, the leaders and the whole assembly and said, 'Our father died in the desert. He was not among Korah's followers, who banded together against the Lord, but he died for his own sin and left no sons. Why should our father's name disappear from his clan because he had no son? Give us property among our father's relatives.'

So Moses brought their case before the Lord and the Lord said to him, 'What Zelophehad's daughters are saying is right. You must certainly give them property as an inheritance over to his daughter. If he has no daughter, give his inheritance to his brothers. If he has no brothers, give his inheritance to his father's brothers. If his father has no brothers give his inheritance to the nearest relative in his clan, that he may possess it. This is to be a legal requirement for the Israelites, as the Lord commanded Moses'."

"Now Zelophehad son of Hepher, the son of Gilead, the son of Makir, the son of Manasseh, had no sons but only daughters, whose names were Mahlah, Noah, Hoglah, Milcah and Tirzah. They went to Eleazer the priest, Joshua son of Nun, and the leaders and said, 'The Lord commanded Moses to give us an inheritance among our brothers.' So Joshua gave them an inheritance along with the brothers of their father, according to the Lord's command. Manasseh's share consisted of ten tracts of land besides Gilead and Bashan east of the Jordan, because the daughters of the tribe of Manasseh received an inheritance among the sons. The land of Gilead belonged to the rest of the descendants of Manasseh."

Theirs is a court decision that is legally accepted as law in our courts today.

Rahab

This woman is called harlot or prostitute or innkeeper, depending upon the version used.

Was she a woman of ill repute?

Regardless of that, what she *became* is more important than what she *was*. God is not deterred by the darkness of a human heart.

Her faith in and fear of the God of Israel determined her actions, the use of her talents.

She was
 industrious,
 devoted to family,
 clever,
 alert,
 courageous.

She believed what she heard about Israel and their God, and her faith in that God led her to be of use to the spies, and ultimately, to the entire nation.

God does not wait for perfection in the life of a person before He uses that individual as His instrument.

In the Bible we are told nothing of Rahab's life with Israel, her marriage, or her family except in Matthew 1:5 where she is named in the lineage of Christ as wife of Salmon, mother of Boaz; great grandmother of David.

Her faith accords her mention in the honor roll of the faithful, (Hebrews 11:31); and James honors her as an example of works. (James 2:25).

God is always in motion toward us, working with us WHERE WE ARE, AS WE ARE.

His power changes us when we respond to Him.

For Private Meditation or Class Discussion

1. What trait did Miriam have as a child?
2. In Israel what was Miriam called?
3. Name some of Miriam's:
 a. talents
 b. faults
4. What complaint did the daughters of Zelophehad have?
5. Of what tribe were the daughters of Zelophehad?
6. What law resulted from their petition?
7. Who was Rahab?
8. Name some of Rahab's talents.
9. What determined Rahab's use of them?
10. What great honor is Rahab's?

Chapter Nine

DEBORAH, RUTH, AND ABIGAIL

Judges 4 and 5; Ruth; 1 Samuel 25; 30:3-20; 2 Samuel 2:2-4

A Homemaker in Politics

Deborah lived at a time when Israel had received their allotments in the promised land and refused to keep the commands and statutes of God. Her greatest service came in time of war. She was a prophetess, the wife of Lappidoth. No other mention is made of her husband.

It seems to be a safe assumption that the men of Israel had abdicated their role of leadership. The text indicates that Deborah was leading Israel from her home where she was placed at the height of political power by common consent of the people. In addition to the roles of wife and homemaker she served as:

counsellor of her people,

judge of their disputes, and

deliverer in time of war.

She sent for a military man, Barak, to go to Mount Tabor where God had promised to lure Sisera, commander of the enemy army and deliver him into Barak's hands.

Barak seemingly was a man of the times and says to Deborah, "I won't go unless you go with me!" Deborah agreed to go with Barak, assuring him that there would be no honor in it for him, for the Lord would hand Sisera over to a woman.

So Deborah went with Barak, and directed the battle strategy with the help of the Lord. Jael was the woman who "pegged" Sisera by driving a tent peg through the temple of his head into the ground.

In the victory song that Deborah and Barak sang God is given *all* the glory and honor.

The only mention of Deborah's motherhood calls her a mother in

Israel (Judges 5:7).

"And the land had rest forty years" (Judges 5:31).

Ruth, the Foreigner

Ruth, the Moabite woman, is the third woman named in the genealogy of Christ. She no doubt lived during a time when Deborah was remembered, for she lived during the days when the judges ruled, and an Old Testament book bears her name.

She expresses her affection for her husband in her loyalty to his mother, his people, his country and his God. There is no record of self-pity and complaint. Her love for Naomi penetrated the barriers of race, lifted her out of poverty and obscurity, and her son's name was famous in Israel. He was Obed, father of Jesse, father of David.

Her love demonstrated love between two hostile nations (Moab, son of Lot, and Israel), as well as love between a mother-in-law and a daughter-in-law. Ruth's statement of allegiance to Naomi, recorded in Ruth 1:16-17 is much quoted and is often used in wedding ceremonies.

Was Naomi manipulative when she sent Ruth to Boaz? In Boaz we see another case of levirate law.

Ruth loved, was consistently lovable, gave love, and received love. Like Tamar and Rahab she is named in Matthew 1, in the genealogy of Christ our Lord.

Abigail

Abigail was the wife of a very wealthy man named Nabal, who lived at Carmel. She was an intelligent and beautiful lady, but her husband was surly and mean in his dealings.

David had been anointed king by Samuel, but was still a refugee from deposed king Saul when Abigail came into his life. David had a following of about 600 men, malcontents, men in distress or in debt, scripture states. While hiding in their desert stronghold David and his men had mingled with the servants of Nabal, protecting them and the 3,000 sheep they tended.

Now it was shearing time, a period of feasting and gaiety. Knowing the man's wealth David sent some young men to request food and provisions from Nabal. He was insulting to the young men who returned to David and reported what happened. David armed 400 men, leaving 200 with their supplies and proceeded to go to Nabal with the intention of wiping out his male population.

Abigail was a woman whom the servants trusted and could talk with. These servants knew David and his men, and they told Abigail how they had been protected by David's company, how Nabal had in-

sultingly refused their request for food, and that disaster lay ahead if something was not done quickly.

Abigail lost no time getting together bread, wine, meat, and grain and dried fruit, and accompanied the servants to meet David and deliver the supplies. She very wisely refrained from telling drunken Nabal what she was doing.

The two parties met in a mountain ravine; Abigail with her servants and supply-laden donkeys, and an angry vengeful David with 400 armed men. Abigail quickly got off of her donkey and fell at David's feet with her face to the ground. She immediately assumed all blame for the situation, asked David to ignore wicked Nabal and let her speak.

She addressed David as master and accredited the Lord with having kept David from avenging himself with bloodshed. Abigail no doubt knew of Saul's pursuit of David and may have known he was the future king. She did know David's God and His protecting hand over David, for she says to him, "Now since the Lord has kept you, my master, from bloodshed by avenging yourself with your own hands....please forgive your servant's offense. The Lord will surely make a lasting dynasty for my master because he fights the Lord's battles." She continues by saying that when he comes to that point in time he will not have on his conscience the staggering burden of needless bloodshed, and asks to be remembered by him.

David is impressed by the good judgment of this lovely lady and accepting her gifts he thanks her for stopping him. Abigail then returns home to confront Nabal. In her wisdom she waited until the surly man was sober to tell him she had spared his life and that of his men. Wicked Nabal had no gratitude in his heart which failed him, and he turned to stone.

Abigail's faith in doing the right thing was so great that she was able to act on it without hesitation in a tight situation. She *accepted* her husband as he was with no debilitating self-pity. There is no indication that she went to David for personal gain, nor with any thought of changing her husband. She was acting as an adapter to and a protector of her husband.

After Nabal's death David praised the Lord for avenging Nabal's evil treatment of him, and for preventing his bringing wrong doing down upon his own head. Later he sent a proposal to Abigail to be his wife. She quickly accepted and attended by five maids she went with the servants to become David's wife.

As his wife her life was not easy. She joined his life as a fugitive

from Saul; no longer was she the wife of a wealthy man with an established home. When the Philistine king gave David the city of Ziklag he moved his two wives, Ahinoam of Jezreel and Abigail there.

The Amalekites ransacked and burned Ziklag taking these two women and their children captive. David pursued them, recovered everything, including his family, and destroyed the Amalekites, accomplishing what Saul had failed to do.

In the course of time David moved to Hebron where Abigail saw her husband anointed king over Judah.

For Private Meditation or Class Discussion

1. What three titles are given to Deborah?
2. In what place did Deborah officiate?
3. What was the result of Deborah's work? (Judges 5:31).
4. For what is Ruth best known?
5. What nationality was Ruth? (Genesis 19:37).
6. What great honor was given Ruth?
7. Why was David wandering from place to place?
8. Describe Abigail.
9. How did Abigail prevent David from avenging himself?
10. As David's wife did Abigail live like a queen?

Chapter Ten

OUTSTANDING MOTHERS OF THE OLD TESTAMENT

Exodus 2:1-10; Acts 7:20; Hebrews 11:23; 1 Samuel 1 - 2:10; Acts 3:24; 2 Samuel 21:1-15; 1 Kings 17:7-24

Jochebed $Ex\ 6:20,\ Nu\ 26:59$

Jochebed was a Hebrew woman of the tribe of Levi; the wife of Amram, a grandson of Levi. As a mother she bore:

Miriam, a prophetess and singer in Israel,

Aaron, high priest of God in Israel, and

Moses, lawgiver and deliverer.

Jochebed was pregnant with her third child during agonizing times. The Hebrews were slaves of the Egyptians and the king had decreed that all baby boys born to Hebrew women must be killed. When Jochebed's fine son was born she looked at this babe and saw that he was no ordinary child. The parents were unafraid of the king's decree, and dependence on God led this mother to arrange to nurture her own son.

In the short time she had him with her she instilled in Moses such KNOWLEDGE and FAITH in God that it stayed with him throughout his life. The foundation he received of his mother in that godly home qualified him to become in later life the deliverer of his people from bondage.

What a wonderful heritage for a mother to have all of her children serve as useful servants of our God!

Hanah, wife of Elkanah

Elkanah was an Ephraimite who took his family annually to Shiloh to make the yearly sacrifices to God as commanded in the Law of Moses. He and Hannah had a compatible marriage but a childless

one. Hannah was a *counterpart*, loved and adored. She received a double portion of sacrifice, but she was continually irritated into weeping by Peninnah, Elkanah's wife who had given him children.

Trying to console his beloved Hannah Elkanah said, "Don't I mean more to you than ten sons?" As a *completor* Hannah had been denied lifegiving ability. Being a woman of faith she prayed diligently to God for a son.

One very remarkable thing about Hannah is the depth of her faith. After pouring out her heart to God requesting a son *"she went her way, ate something, and was no longer downcast."* How many women do you know who can handle their problems with such faith that they take their burden to the Lord, *leave* it there, and go happily about other business?

Hannah had no ulterior motives in asking for a son; there is no indication in scripture that she wanted to "show Peninnah", or to flaunt her son. Her desire was to have a son so he could serve God.

Mothers, what do you want for your sons? Is your goal for them one that would see them servants of God? Are you training your son from infancy to qualify as a scriptural elder in the Lord's church? Are you training him to accept leadership in his own home someday? This type of training in the home could have eliminated our present involvement with Women's Liberation!

God gave Hannah the son she requested. She was a wise, prudent, devoted mother who possessed fortitude and vision. Her son grew before the Lord and through him his mother gained immortality. Samuel was the last judge of Israel and a prophet in Israel. He anointed Saul, the first king of Israel, and young David, the man after God's own heart.

Hannah turned her son over to God, free of her domination, free to become his best self in serving God.

Rizpah

A wife and mother who is not talked about often in our Bible studies is Rizpah. Her name is mentioned only three times yet God saw fit to record for our learning this very touching story of a mother's love and devotion.

Rizpah was a concubine of King Saul and bore him two sons, Armoni and Mephibosheth (not to be confused with Mephibosheth, son of Jonathan). These two sons plus five grandsons of Saul were handed over to the Gibeonites to avenge Saul's cruelty to them. They killed the seven men of Israel and left their bodies where they fell.

Rizpah took sackcloth and spread it out for herself on a rock. From the beginning of the harvest until the rains came she sat by these

bodies and did not let the birds or the wild animals touch them. This grieving mother was powerless to prevent the murder of her sons and had no place to bury them, but no political power could prevent her watching over and protecting their dishonored bodies.

This woman's love for her husband is demonstrated in her vigil over his sons and grandsons. How long she kept her wake we do not know; scripture says from the beginning of the harvest until the rain came. This could have been four to six months, according to agricultural information of that time. However, these men were sacrificed because of a three year famine (1 Samuel 21:1) and since there is no other mention of this event a definite time cannot be established.

Regardless of the length of her mourning, the lonely vigil merited the notice of the Holy Spirit in recording Israel's history. When David, the king, was told what Rizpah had done he went to Jabesh Gilead and took the bones of this woman's husband, Saul, of his son Jonathan, and the bones of the seven men she had watched over and buried them. After this God answered prayer in behalf of the land.

The Widow of Zarephath

One more Old Testament mother needs our attention. She was a hungry mother with a hungry child and was about to cook the last of her food for them when she was given a test of self-denial and faith.

Elijah, the prophet of God, came to the gate of Zarephath where she was gathering sticks for her fire and requested a drink of water and a piece of bread. After hearing of the destitution of the woman he told her to go ahead and bake the last of her flour and oil, but to make a small cake for him first and bring it to him before making something for herself and her son. "For this is what the Lord, the God of Israel says, 'The jar of flour and the jug of oil will not be used up until the day the Lord gives rain on the land.' "

The widow did not rationalize that God would expect her to care for her child before feeding some one else; she did as Elijah told her to do. As a result there was food every day for Elijah, the woman and her son.

Later this woman's son died. She railed at Elijah for killing her son. Elijah replied, "Give me your son." He took the boy to his room and cried out to the Lord to restore life to the child. The Lord heard Elijah's cry and the boy was restored to his mother. Then the woman said to Elijah, "Now I know that you are a man of God and that the word of the Lord from your mouth is truth."

Miracles under the Old Testament served the same purpose that they did under the New Testament, to confirm the Word of God as truth.

63

For Private Meditation or Class Discussion

1. Who was Jochebed?
2. When pregnant with her third child what courage did Jochebed show?
3. In the short time she had her youngest with her what did Jochebed teach him?
4. Was Jochebed a successful mother?
5. What was lacking in Hannah's life? What did Hannah do about it?
6. Did Hannah fret about whether or not God heard and would answer her? Explain.
7. What did Rizpah's unusual display of devotion tell about her?
8. What test of faith was given the widow of Zarephath?
9. What two miracles did she experience?

Chapter Eleven

THREE QUEENS

2 Samuel 11:1 - 12:25; 1 Kings 1:11 - 2:40; 1 Kings 16:31; 18:4 - 19:2; 21:1-26; 2 Kings 9:29-37; Esther 1:1 - 9:32

Bathsheba

David the king was in Jerusalem while his army was destroying the Ammonites under Joab, the general. One spring evening he walked on the palace roof and saw a beautiful woman bathing. He sent for her and slept with her.

Bathsheba was one of King David's subjects, and she could not resist his command. Our only insight to her character is her message to David, saying, "I am pregnant." She left all of the consequences in the hands of the king who had sent for her.

One sin leads to another. David lusted for her, and impregnated her, then tried to trick her husband into sleeping with her to cover his own sin. When this failed David murdered her husband at the battle front and married Bathsheba, but the child died.

Bathsheba bore David another son, Solomon, who succeeded his father to the throne, and gave him three other sons, also.

When Adonijah usurped the throne of David, Bathsheba and Nathan the prophet intervened so that Solomon was placed on the throne. She still had the respect of the aged king; a wife who showed courtesy, wisdom and vision, a counterpart, a completor, an adapter.

She was the influential and much-loved mother of the wisest of all men; and is the fourth woman to be mentioned in the genealogy of Christ.

Her last recorded act was to make a request of Solomon, as she sat on a throne on his right hand, for Adonijah, the step-son who had usurped the throne from Solomon.

Jezebel

Ahab reigned in Israel during the period of the Divided Kingdom. Being the son of Omri, the most evil king Israel had to that date, it is no surprise to read of Ahab, "He not only considered it trivial to commit the sins of Jeroboam, but he also married Jezebel, daughter of the king of the Sidonians, and began to serve Baal and worship him."

Here we find a queen of very strong character. She brought her own religion into Israel and killed off the Lord's prophets. She had 850 prophets of foreign gods eating at her table, and had persuaded her husband, the king, to build a temple to Baal.

She threatened to kill the prophet Elijah after his challenge to Baal on Mount Carmel. When her sullen husband pouted because Naboth would not sell Ahab his vineyard, Jezebel said, "Is this how the king of Israel acts? Cheer up! I'll get you Naboth's vineyard." She arranged to get Naboth stoned to death, then told Ahab, "Get up and take possession of Naboth's vineyard."

Jezebel was an agressive, domineering, self-willed woman. She is a prime example of man's inclination to follow the influence of his wife! She is an outstanding example of the kind of influence a woman should not be. "There was never a man like Ahab, who sold himself to do evil in the eyes of the Lord, *urged on by Jezebel his wife*" (21:25).

Elijah prophesied, "Dogs will devour Jezebel by the wall of Jezreel." We find this fulfilled in 2 Kings 9:29-37.

In Jezebel we see a very destructive woman - epitomized in the book of Revelation as a symbol of seduction and idolatry.

Have many know of a sweet little girl who has been named Jezebel?

Esther

Esther was an orphaned Jewess who had been brought up in the Babylonian captivity by a cousin, Mordecai, of the tribe of Benjamin. He had taken her as his own daughter and she had grown up to be "lovely in form and features."

When King Xerxes (Ahasuerus) deposed queen Vashti, a search was made for beautiful young virgins in the kingdom to be placed in the charge of Hegai, the king's eunuch, to be beautified for presentation to the king. Esther was taken to the king's palace and soon won the favor of Hegai. He gave her special food and beauty treatments, assigned her seven maids and moved her into the best place in the harem. After a year of preparation when the women were presented to the king he chose Esther, who he did not know was a Jew, and crowned her queen instead of Vashti.

Esther was a lovable, humble person, gaining the confidence of

those around her. Mordecai had kept a watchful eye on his foster daughter all the while, and when he learned of a conspiracy to assassinate Xerxes he told Queen Esther who reported it to the King, carefully giving credit to Mordecai.

She soon learned that her husband's favorite official, Haman, was an enemy to her people, the Jews, and had made a decree that all Jews must bow down to him. Mordecai refused to bow to Haman. This so angered Haman that he decreed all Jews would be killed. Mordecai then pleaded with the queen to appear before the king and plead for her people.

Esther was hesitant, knowing that anyone who entered the king's court without being called could be executed. Mordecai's reply was, "Do not think that because you are in the king's house you alone of all the Jews will escape. For if you remain silent at this time, relief and deliverance for the Jews will arise from another place. And who knows but that you have come to royal position for such a time as this?"

Her answer was a request for Mordecai and all the Jews of Shushan to fast for her for three days and she and her maids would do the same, then she would approach the king even though it was against the law to do so. "If I perish, I perish."

At the end of the fast Esther approached the king and he was pleased with her. He asked what she wanted and promised her anything, even half of his kingdom.

How Esther saved her people is very interesting reading. To this day orthodox Jews celebrate the feast of Purim in celebration of Esther's deliverance of her people.

As a young woman, orphaned and a captive with her people in a land far, far from home, Esther grew up to be an obedient, God fearing person. Her purity, her humility, and her respect for leadership qualified her to be useful to her people in the worst circumstances. God had promised to save a remnant of Israel through whom His Anointed One would come.

As a queen Esther showed tremendous courage and used her influence wisely. Perhaps it could be said of her that she was cunning in her plan to get rid of Haman. In a word, "she gave him enough rope to hang himself." Esther allowed herself to be led by her God, and had the wisdom not to run ahead.

Let us all allow God to use us in His way at His own speed. Many of us need to remember that God does not get in a hurry, as we do. "In patience you possess your souls."

For Private Discussion or Class Study

1. What sins did David commit before Bathsheba became his wife?
2. How many sons did Bathsheba give David?
3. What honors were given Bathsheba?
4. For what is Queen Jezebel remembered?
5. What good traits did Jezebel have? (Name at least three).
6. What went wrong with Jezebel?
7. Name some disadvantages of Esther's background.
8. What things made Esther special?
9. As queen of Babylon did Esther forget her people?
10. Mordecai used a persuasive statement to get Esther to go to the king on behalf of the Jews.
 a. What was his much-quoted statement?
 b. What was her reply?

Chapter Twelve

THE EPITOME OF WOMANHOOD

Proverbs 31:1-31

Advice from a Mother

Proverbs 31 is a well known chapter from the Old Testament. Many lessons have been taught, many sermons preached and much has been written on the worthy woman of Proverbs 31:10-31, but little has been said about the first ten verses of the chapter.

In verse one we find that the writings to follow are the sayings of King Lemuel, "an oracle his mother taught him": she warns against unchaste living and the dangers of strong drink which "is not for kings, O Lemuel." He is to abstain from drunkenness, injustice, oppression and insensibility, and is to practice justice and be compassionate, pleading the cause of the poor and needy.

A Mother's Standard

The next twenty-two verses are the standards set forth by a good woman, the mother of a king, for the woman who would be his wife and her daughter-in-law, a future queen. The woman described is the epitome of the creative woman, with no destructive qualities!

She is the A-Z of a perfect wife; one whom a mother would pick out for her son to be queen. She has been held up before women for centuries as the person every wife, mother and homemaker should be, and many have suffered a guilt trip because of their failure to measure up to this noble person.

Let us take a careful look at this passage. It is an acrostic poem of the Hebrew alphabet and is written in couplets. It is an excellent memory exercise, and awareness of its literary form will be helpful in committing it to memory.

The Wife of Noble Character

This creative woman is a:

Counterpart, the wife to the husband;

Completor, her children call her blessed;

Adapter, her husband has full confidence in her;

Protector, she brings him good, not harm;
her husband is respected at the city gate;

Pursuer, "Many women do noble things but you surpass them all,"
her husband says to her.

This wife of noble character is:

trustworthy - her husband has full confidence in her;

loyal and faithful - she is an asset to him in every way;

industrious - works with her hands; is an early riser;

well organized - an economist of time;

a good manager - verse 15

ambitious for her family - verse 16

healthy - verse 17

financially capable - verse 18

skillful - verse 19

charitable - verse 20

has vision and foresight - verse 21

she and her house are well-groomed - verse 22

honors her husband - verse 23

resourceful - verse 24

dignified - verse 25

wise and instructive in her speech - verse 26

a moral manager - verse 27

praiseworthy - verse 28, 29

Some Overlooked Aspects

These attributes of the worthy woman are usually the picture set forth for the modern woman to use as her standard for life, and this is good if one does not overlook some very important aspects of this woman's life. Her husband provided her with:

the best materials available with which to work: wool, flax and linen; imported foods; servants; a well equipped house; a husband who was respected as a leader, and children and a husband who gave her compliments and praise for her efforts.

The key statement is made at the beginning of verse 10; WHO CAN FIND A WIFE LIKE THIS?

To live up to the standards set up by this queen mother for her son's

wife is much like our efforts to reach the stature of Christ. It is a goal for which we strive but never quite reach.

Today's Woman

Today's woman probably comes nearer to this attainment than she realizes. One who is a wife, mother and homemaker is a

dietician,	counselor,
chef,	taxi-driver,
decorator,	tutor,
nurse,	seamstress,
fashion model,	entertainer,
financial wizard,	psychologist,
personnel manager,	hostess,
lover,	comforter,
spiritual confidante,	florist,
food processor,	cleaning expert
answering service,	companion
advisor,	sounding board
purchasing agent.	

She is worth far more than rubies! She is fulfilled! Her husband honors her and her children rise up and call her blessed!

This honored woman has her priorities straight. The woman who fears the Lord and truly makes Him the Lord of her life is the truly beautiful woman, and she shall receive praise.

This worthy woman will be treated like a queen by the man in her life, her husband, and he will find himself treated like a king.

CALL HER BLESSED

Mary Ann Ramsey

Proverbs 31

Who can find a good wife? She is worth more than a well paying job or a high college degree.

Her husband trusts her with his love, his children, his home, his checkbook and his reputation. His income will be adequate for she will not desire all that she sees.

She gives him love, honor and obedience, and never tries to belittle, discourage or hurt him all the days of her life.

She knows and finds materials of good quality, and works without nagging or complaining about her many tasks.

She is like the grocer. Her cupboards are well-stocked with various food so that family and guests may be well fed.

She gets up early and prepares breaakfast for her family; her children are taught to do their chores, and the day is begun in an orderly fashion.

She studies the needs of her family, the fitness and value of property and they buy a house. She plants fruits and vegetables to garnish the table, and flowers so they may know beauty.

She is careful to get exercise, rest and proper food so she may be strong and she is diligent to maintain her health.

She sees that what she does is good and helpful. She is ever watchful so that she is aware of her family's needs.

With her needle she sews and mends: her hands guide the iron so her family may be well-groomed.

She is ever ready to give help to the poor, and reaches out to those in need with kindness and understanding.

As the seasons arrive, her family's needs have been anticipated and met, and they are well-clothed.

She plans and prepares for herself also. Her clothing is lovely, modest and appropriate.

Her husband is respected in the community where he works with the church and at his job.

She uses her time and sells the products of her skills. She delivers her specialty to the buyer.

She is sensible, chaste, poised and kind and is confident she is able to handle whatever may come to pass.

She is careful to say that which is wise and seemly, and with love and kindness she teaches by word and example.

She is concerned about all that her family does, and guides them into the right choices. She does not indulge herself with useless pastimes.

Her children call her pleasing to God and show by their lives that this is so. Her husband also calls her beloved of God, and says: "You have made me happier than any other woman could have, and with you I have been able to give more of myself to the Lord.

All the attractions of the body are not sufficient nor lasting but the woman who serves the Lord will be the wife and mother God would have her to be.

Her children and grandchildren and those whom she has helped will seek her out all of her days, and her Godly life and influence will be known in the church and in the community.

Reprinted with permission of *Christian Bible Teacher* magazine.

For Private Meditation or Class Discussion

1. Whose teaching do we find in Proverbs 31?
2. In the first 9 verses what is the primary teaching?
3. What is set forth in the next 22 verses?
4. What is the literary form of this passage?
5. In what ways is this woman creative?
6. Name some traits of this worthy woman.
7. Name some overlooked aspects of this woman's life.
8. What is the key statement of the passage?
9. Living up to this standard can be compared to what?
10. How does *Today's Woman* measure up to the Worthy Woman?

Chapter Thirteen

AGED ELIZABETH AND YOUNG MARY

Matthew 1:18 - 2:23; Luke 1:5 - 2:52; John 2:1-12; 19:25; Matthew 12:46-50; Mark 3:34,35

Elizabeth

The wife of Zechariah the priest was well past the age of childbearing when the angel Gabriel appeared to her husband with the message that Elizabeth would bear a son. They were to name him John and he was to be a Nazarite; he would make ready a people prepared for the Lord. Zechariah questioned the angel because from his human point of view this was a physical impossibility.

Zechariah lost his speech because of his unbelief of the good news the angel brought, and when his service at the temple was completed he went home. After a time the aged Elizabeth "became pregnant and for five months remained in seclusion."

Mary

In the sixth month of Elizabeth's pregnancy God sent the angel Gabriel to Nazareth in Galilee to a virgin named Mary. This young woman was engaged to be married to a man named Joseph, a descendant of David.

The angel's greeting startled young Mary, but Gabriel said, "Do not be afraid, Mary, you have *found favor* with God." This young woman lived such a life of consecration, devotion and purity that she *found favor* with the God of heaven. She was already committed to the Lord as His servant, and when the angel told her that she would have a son who would be named Jesus, called the Son of the Most High, and occupy the throne of David she had no problem saying "Here I am. Let it be as you say."

A Visit with Elizabeth

The angel told Mary the news about Elizabeth, and Mary hurried to the town in Judah to the home of Zechariah to greet Elizabeth. At the sound of the greeting Elizabeth's baby leaped in her womb and she was filled with the Holy Spirit.

There was no jealousy in the heart of the aged Elizabeth because Mary was carrying the Messiah; only a blessing for Mary came from her lips. She felt favored that the Mother of the Lord would come to her.

We are not told why Mary rushed to see Elizabeth. Both had been visited by the Lord, and each would bear a child for a special purpose. Did Mary fully understand her situation? Would her parents and family understand that this young woman was totally innocent of any wrong? How would she tell them of her pregnancy? Three months with Elizabeth, who was carrying a miracle baby, too, helped give Mary balance, and to tell her family and Joseph her secret.

Mary and Joseph

Joseph had to be shocked by her news! The Hebrew law called for an unwed mother to be stoned to death, but Joseph offered to divorce her quietly because he was a righteous man and did not want to expose her to public disgrace. How did Joseph feel? Did he believe her child was God's Son, the Messiah? Why did he offer her a divorce? Whatever he thought, his fears were allayed by a visit from an angel who said, "Joseph, Son of David, do not be afraid to take Mary home as your wife." Assured that Mary's son was conceived of the Holy Spirit Joseph and Mary together awaited the birth of the Messiah, but had no union until her son was born.

His Name Is John

Shortly after Mary's return to Nazareth Elizabeth gave birth to a son. Her neighbors and relatives rejoiced with her because the Lord had shown her great mercy and on the eighth day when the baby was to be circumcised they expected him to be named Zechariah. Elizabeth said, "No! He is to be called John." They insisted that no one of their relatives had that name and asked Zechariah what he would like to name the child. He asked for a writing tablet, and to everyone's astonishment he wrote, "His name is John."

Immediately Zechariah was able to speak and he praised God. The incident was the topic of conversation throughout the hill country of Judea, with everyone asking, "What is this child going to be?" for

the Lord's hand was with him.

Elizabeth's son was the fulfillment of the prophecy in Isaiah 40:3-5 of a voice of one calling in the desert, "Prepare the way for the Lord....all mankind will see God's salvation."

Mary Has A Son

Very late in her pregnancy the decree of Caesar took Mary and Joseph some seventy miles from Nazareth to Bethlehem. No doubt their travel was slower than the throngs travelling to their birthplaces for the census, for they found no room in which to rest. So Mary gave birth in a stable with the animals and laid the Savior of the world on the straw in a feeding trough, fulfilling the prophecy that the Messiah would be born in Bethlehem.

Here we see that truth of Isaiah's statement, "My thoughts are not your thoughts, neither are my ways your ways," declares the Lord. "As the heavens are higher than the earth, so are my ways higher than your ways, and my thoughts than your thoughts" (Isaiah 55:8,9). Who, among men, would have the King of Kings born in a stable? The only herald of His birth was to the shepherds in nearby fields. They greeted this King, the Messiah, on the night of His birth, then spread the news concerning what they had been told about the child. "But Mary treasured up all these things and pondered them in her heart."

In The Temple

When her son was eight days old Mary and Joseph had Him circumcised and named Him Jesus. Matthew tells us that the wise men (no number mentioned) visited Mary and the child *in a house* in Bethlehem and presented gifts. Thirty days after His circumcision, according to the law stated in Leviticus 12, Joseph and Mary went to Jerusalem to present the child to the Lord, and for Mary's purification.

In the temple was a righteous and devout man called Simeon who had been promised he would not die before he had seen the Christ (anointed one). When Simeon saw Mary bring in the child Jesus he took Him into his arms and praised God saying, "My eyes have seen your Salvation," and to Mary he said, "A sword will pierce your own soul, too." The child's mother marvelled at what was said about Him.

Anna, a prophetess who worshipped and prayed in the temple night and day came to Joseph and Mary, gave thanks to God and spoke about the child to all who were looking forward to the redemption of Israel.

When Jesus was twelve years old Joseph and Mary took Him with

them from Nazareth to Jerusalem for the Feast of the Passover. When He got lost from their group they found Him in the temple sitting among the teachers listening to them and asking questions. When questioned about the anxiety He had given them Jesus replied, "Didn't you know I had to be in my Father's house?" They did not understand "But His mother treasured all these things in her heart."

Mary and Jesus

Our next account of Mary and Jesus together is at the wedding feast in Cana of Galilee where He performed His first miracle of His ministry. Here we see Mary's maternal confidence in her Son when she said to Him, "They are out of wine." When He answered, "Don't bother me," she told the servants to "do whatever He tells you." Jesus turned the water into the best wine at the wedding, revealing His glory and instilling faith in His disciples.

Mary must have realized the meaning of Simeon's words when she heard that her firstborn had been betrayed by Judas and would be crucified. Mary and John, the disciple whom Jesus loved, stood at the foot of His cross. Her innocent Son, God's Son, was hanging there between two thieves being ridiculed and abused. The second of His recorded sayings on the cross was directed to His mother, "Dear woman, here is your son," and then to John He said, "Here is your mother."

Mary may have been at the tomb the morning of the first day of the week when He was resurrected. She was with the disciples in the upper room, after His ascension into heaven, devoting themselves to prayer. No doubt she was in the crowd at Pentecost when everyone there heard the first gospel sermon preached in his own language.

Perhaps now she understood some of the many things she had pondered in her heart. Mary had humbly submitted her life to God and to His plan for her. She was promised no exaltation and did not ask for any. Although she had given birth to the Son of God she now was only one of those to whom He had referred in Mark 3:34,35, "Whoever does God's will is my brother and my sister and my mother."

For Private Meditation or Class Discussion

1. What things did Elizabeth and Mary share in common?
2. How much older was John than Jesus?
3. What special mission was given to John?
4. How did Joseph propose to solve the dilemma of Mary's pregnancy?
5. Why was Jesus born in Bethlehem? Micah 5:2-5.
6. What three events are we told that "Mary pondered (treasured) these things in her heart," or "marvelled at what was said about Him?"
7. After His ministry started, on what occasion was Mary with her Son?
8. When were Simeon's word to Mary fulfilled?
9. What concern for Mary is shown by Jesus as He was on the cross?
10. When is Mary last mentioned in scripture?